Knitting for Beginners: How to Craft, Crochet, Knit Stitches, & Patterns

By Darla Singer

Copyright Info:

Legal Info:

This book in no way, is affiliated or associated by the Original Copyright Owner, nor has it been certified or reviewed by the party. This is an un-official/non-official book.

Preface

We want to take a moment to say thank you for purchasing our guide online. HiddenStuff Entertainment remains one of the top app and eBook publishers online. It is our commitment to bring you the most important information to enrich your life.

We sincerely hope that you find this guide useful and beneficial in your quest for betterment. We want to provide readers with knowledge and build their skills to perform at the highest levels within their topics of interest. This in turn contributes to a positive and more enjoyable experience. After all, it is our belief that things in life are to be enjoyed as much as they possibly can be.

If you are in need of additional support or resources in regards to this guide, please feel free to visit our webpage at Hiddenstuffentertainment.com

Contents

Knitting – How It Is Done

If you are learning how knitting can be done, you will want to admit that it is daunting initially. It is possible that you are considering how it can be done as well as how you need to get started. There are two variables needed for this which are knitting needles and also ball of yarn. I want to get both supplies chosen for knitting in other to ensure that the process is started as soon as possible.

Choosing Knitting Yarn

There are lots of knitting yarns that are out there and sometimes I get confused on which one to make use of. There are times I spend hours trying to go through the various types available. I also look at their colors and textures. This is just wonderful since there is always something new to discover.

Having to choose the best knitting yarn for such a project is one that can be very difficult most especially once you haven't done it before. However, below are some things to help you get your options narrowed down as much as possible.

If you are starting out, ensure that the yarn you are buying is one that is smooth worsted weight. Forget about those yarns that are fanciful for now until you have already undertaken some knitting projects.

Medium worsted yarn weight is what I will be starting out with. Ensure that a color which is light is selected. This will enable you see stiches in a better way.

Your yarn label should be checked out. This is because you will be getting vital piece of information regarding knitting from it.

One thing that you need to always remember concerning knitting yarns is that I will not want to purchase cotton yarns given the fact that they haven't got any stretch. Knitting with them seems difficult. Although they are great to make use of, you need to have gotten some experience under your belt before you can make use of them successfully.

Knitting Needles

Ones That Can Be Used

Another important tool for knitting are knitting needles. There are actually lots of them that you can choose from. This is because they are of various materials such as aluminum, wood, plastic and bamboo. Every knitter has got the ones that he or she does make use of constantly. What you are going to discover over the course of time is that the one to choose from is an experience that is personal.

However, below are a few suggestions which can help you out:

Due to the fact that you are new to knitting, you may want to have all the knitting needles tested out so as to see the one which is most favorable. This is necessary given the fact that just as they are many, that is how their sizes are different.

Alternatively, circular knitting needles can be considered. It is possible to knit flat using them. One good part about them is that they tend to always hold stiches for those projects which are bigger. Every knitter does have the one that he works with. You will definitely be able to find that one which will be most suitable for your use.

There are 2 knitting needles which I usually make use of interchangeably. These are Denise as well as knitters' pride.

Wood or bamboo needles are perfect if you are starting out. Knitting stitches will not slide off your needle easily. Also, you are comfortable making use of them. Aluminum and plastic are very slippery. Therefore, it is possible for knitting to be slipping off the stitches easily. This is actually a choice that is personal.

What Knitting Needle Size Should Be Chosen?
A knitting needle that is of medium size is what I can begin with (medium needles, medium yarns). The suggested sizes are 8 (5mm), 7 (4.5mm), or 6 (4mm). These are sizes which make use of yarns that of medium weight. You will actually feel very comfortable making use of them.

Ensure that the length of the knitting needle is greatly considered if you are buying one. For children, you can go for those ones which measure 7inches in sizes. Move hire up to about 8 – 14 inches.

What I discovered is that lengths which are shorter are always less cumbersome. You will feel at ease making use of them as compared to

those ones which are longer. Even those ones which are meant for children can be made use of easily during practice. Note that once you have started to knit items that are bigger, knitting needles which are longer will be needed. Remember that the knitting yarn's size as well as knitting needle do complement each other. Thin yarn will need thin knitting needles while thick yarn will need thick needles.

Learning knitting stiches which are basic is always going to begin from having to get knit stitch learnt. With this very stitch, every other stitches will then become possible. I love this one the most.

When all the stitches on all the rows get knitted, such is referred to as Garter stitch. If you are trying to learn how knitting can be possible, you are discovering the process of Garter stitch.

Garter stitch is something I have come to like. Though I understand that there are people who may find it to be very boring. I also feel the same sometimes. This is something I usually take part in whenever I feel bored. When this happens plain Garter stitch is knitted.

Knitting Stitches

These pictures show knitting the English way whereby the yarn is being held in your hand (right). It can also be referred to as throwing, right – handed or American style.

Casting On 10 – 12 Stitches

Using the cast which is on the stitch that is on your hand (left), the knitting needle should be held. Ensure that the working yarn is at your work's back. Have the right needle inserted inside the loop which is on that needle that is left. The needle should be pushed through. Such should be from front to the back.

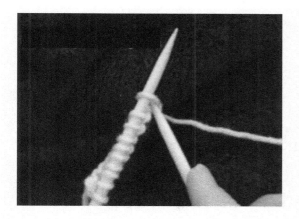 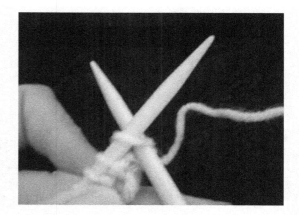

old your knitting needle with the cast on stitches in your left hand. Make sure that your orking yarn is at the back of your work. Insert the right needle into the first loop on the left ind needle. Push the needle through from front to back.

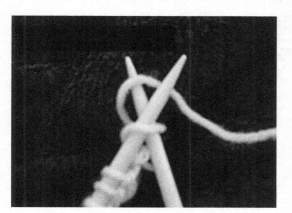 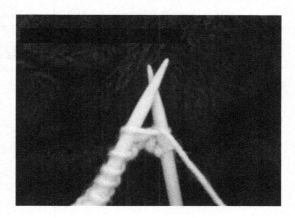

With the yarn that is working, get it wrapped counterclockwise around the righthand needle thereby helping to bring it between 2 needles. It should be a little bit snugged up.

How You Can Knit

KnitStitch

Just as the needle (right) is still being wrapped around by the yarn, right knitting needle should be brought through the initial or first loop on the knitting needle that is left. This will enable the stitch which has newly been formed to get completed. Ensure that the formed stitch is continuously pulled. The first or initial stitch should be slowly dropped of the knitting needle that is left.

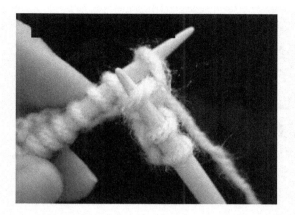 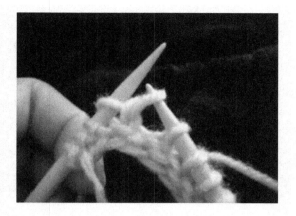

With the yarn still wrapped around the right needle, bring right knitting needle through that firs loop on the left knitting needle to complete the newly formed stitch. Keep pulling that newly formed stitch through the loop on the left needle.

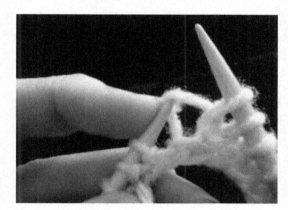 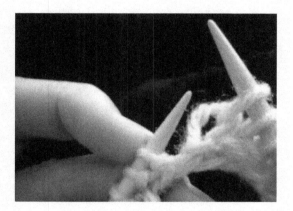

What Should I Do When It Get To The Row's Ending?

Your right needle should be moved with the stitches which are new on it over to your left. The knitting needle which is empty should be put in your right. After that, you can now start over. Turning your workis what this is actually referred to. The right side which it is facing is where knitting should start from. You can then get the work turned while the wrong side will not be facing you. It just continues like that.

Don't forget that when both sides are garter stitch, they will appear similar and there will not be a side that is wrong. Just continue practicing until you get very comfortable with it. The more practice you undertake, the easier it will become.

Conclusion

Once you start to implement the steps outlined you will be able to amazing stitches, patterns, and objects. Good luck and enjoy!

9 780359 157051